Awake, My Soul

Devotional Inspiration for Women

JANICE THOMPSON

BARBOUR
PUBLISHING

Member of the
Evangelical Christian
Publishers Association

Contents

Introduction

Awake, my soul!
PSALM 57:8 NIV

An act of kindness.
A much-needed hug from a friend.
A word of encouragement.
A timely, but unexpected gift.

These are the moments that awaken a woman's soul
to the undeniable love of her heavenly Father—
the One who sees and meets her every need.

Each of these 200 devotional readings will
speak to your heart as you experience the
unchanging and overflowing love of God.
Every inspiring word will draw you more closely
to the Master Creator as you envelop your soul
in the perpetual love found only in His Word.

Deep and Wide

No Boundaries!

For as high as the heavens are above the earth, so great is his love for those who fear him; as far as the east is from the west, so far has he removed our transgressions from us.

PSALM 103:11–12 NIV

God's love for us surpasses all boundaries. If we go to the highest highs or the lowest lows, He will meet us there. No matter where we are in our faith journey, He stands with arms wide, ready to forgive our sins. We don't understand this kind of love. Then again, if we could understand it, perhaps it wouldn't feel like such a gift. Thank God for a love that knows no boundaries.

Too Wonderful to Be Measured

I want you to know all about Christ's love,
although it is too wonderful to be measured.
Then your lives will be filled with all that God is.

EPHESIANS 3:19 CEV

Have you ever thought about measuring God's love? There's no ruler long enough! No map wide enough. No ocean deep enough. God's love is immeasurable. It is, as we sang as children, deep and wide. If we spent our lives trying to make sense of it, it would only outrun us in the end.

A Love That Reaches to the Heavens

Your love, O Lord, reaches to the heavens,
your faithfulness to the skies.

PSALM 36:5 NIV

Isn't it interesting to picture God's love sweeping over all of humanity? From His throne in heaven, He pours out this marvelous fountain of love. And with His arms spread wide on the cross, it flowed as a sacrifice for all. His love reaches us when we're in the low places and chases after us when we're in seasons of rebellion. Praise God for His sweeping love!

Nothing Can Separate Us

In all these things we are more than conquerors through him who loved us. For I am convinced that neither death nor life, neither angels nor demons, neither the present nor the future, nor any powers, neither height nor depth, nor anything else in all creation, will be able to separate us from the love of God that is in Christ Jesus our Lord.

ROMANS 8:37–39 NIV

Have you ever felt as if you're unlovable? Here's some great news: Nothing you've ever done— no sin you've committed, no wicked thought that's flitted through your brain, no temptation you've fallen into—can separate you from God's love. Even when you feel far removed from Him, He's still there, extending His arms of love.

Unconditional Love

Come live in my heart and pay no rent.
SAMUEL LOVER

Unconditional love doesn't say,
"I'll love you *if*." No, real love doesn't
charge rent. It's a gift, one we
freely receive and freely offer to
others. Today as you consider God's
unconditional love for you, why not
thank Him that the only cost was the
one He paid through the death of
His Son on the cross for your sins.

The Greatest Gift

For God So Loved. . .

For God so loved the world, that he
gave his only begotten Son, that
whosoever believeth in him should not
perish, but have everlasting life.
JOHN 3:16 KJV

If we spent the rest of our lives trying
to figure out the heart of God for His
people, we couldn't do it. What kind of
father gives his son as a sacrifice for
the lives of countless billions of people?
And all He asks in response is that we
believe so that we can receive His
immeasurable gift of love. Today open
your heart to believe—and receive!

Laying Down Your Life

"Greater love has no one than this, that he lay down his life for his friends."

JOHN 15:13 NIV

Have you ever wondered if you would be willing—or able—to lay down your life for someone else (say, a family member, child, or spouse)? Could you do it? Very few human beings have literally laid down their lives. However, Jesus, who lived a sinless life, willingly gave Himself as a sacrifice for us, His friends. He laid down His life so that we can have life eternal. Oh, what love!

This Is What Love Is. . .

*This is how we know what love is: Jesus
Christ laid down his life for us. And we ought
to lay down our lives for our brothers.*
1 JOHN 3:16 NIV

Do you want to know what love is? It's the
ability to sacrifice—to lay down personal
wants and wishes—for others. Jesus gave
us the ultimate example of sacrificial
love when He walked up Calvary's hill
and took our place on the cross. When
we let go of selfishness and pride and
put others first, we're following His lead.
What an awesome display of love!

His Great Love

But God showed his great love for us by sending Christ to die for us while we were still sinners.

ROMANS 5:8 NLT

Have you ever tried to think up ways to show others that you love them? Maybe you send roses or write a great letter. Perhaps you go out of your way to do something sacrificial so that they will recognize your great love. God went out of His way to show us how much He loves us by offering His only Son. What an amazing example of how to love!

The Gift of Love

Love is, above all, the gift of oneself.
JEAN ANOUILH

Wondering what gift you can give the
ones you love? Why not the gift of you?
The people in your life need your time,
your energy, your attention, and your
love. They desire your encouragement,
your energy, and your uplifting smile.
All of the best presents you could
offer would never come close to
the one they most desire—you!

Love's Fruit

A Fruit Tree

*But the fruit of the Spirit is love, joy,
peace, patience, kindness, goodness,
faithfulness, gentleness and self-control.
Against such things there is no law.*

GALATIANS 5:22–23 NIV

If love were a tree, it would be heavy with
fruit. What fruit, you ask? Oh, many varieties!
When you love people, you're naturally
more patient with them. And you treat them
kindly and use self-control. You're faithful to
those you love, and you respond in a gentle
fashion. These things are the "fruit" of a
love relationship that comes from on high.

The Power of Life and Death

The tongue has the power of life and death,
and those who love it will eat its fruit.
PROVERBS 18:21 NIV

Have you ever been around people who have a sharp tongue? They don't come across as loving, do they? No, they convey just the opposite. The Bible tells us that the power of life and death is found in the tongue. When we speak words of love, we bring life. When we offer sharp retorts and ugly criticism, we imply that our love has limitations. Today make a choice to spread life. Spread love!

A Crop of Love

"I said, 'Plant the good seeds of righteousness,
and you will harvest a crop of love.' "

HOSEA 10:12 NLT

Imagine yourself as a farmer out in the field
planting good seeds. What sort of crop do
you think you will yield? An awesome one,
no doubt! Harvesting love is much like that.
When we start with the right attitude and
a heart toward God and others, love always
follows. We need to start with softened
hearts, though, so spend some time today
asking the Lord to break up the hard places.

A Love That Remains

"Remain in me, and I will remain in you.
No branch can bear fruit by itself;
it must remain in the vine. Neither can
you bear fruit unless you remain in me."
JOHN 15:4 NIV

Want to know how to have a love that
remains? One that will never die? Remain
in the Lord. Abide in Him. If you're in a
fruitless season of your life, double-check
to make sure you're still connected to the
Life-Giver. Once you're grafted into the
vine, fruit will grow—and love will flow!

Love—Active and Fruitful

Love, like truth and beauty, is concrete. Love is not fundamentally a sweet feeling; not, at heart, a matter of sentiment, attachment, or being "drawn toward." Love is active, effective, a matter of making reciprocal and mutually beneficial relation with one's friends and enemies.
CARTER HEYWARD

What do you suppose would happen if you neglected love? If you never used it? If you hid it away from others? Love is active. It's meant to be shown. Used. Given. Received. It's not what we feel; it's what we do. And it's not just meant to be shared among friends and loved ones. No, "active" love spills over onto others—in the workplace, the grocery store, and even when we're driving!

Love Is a Choice

It's Your Choice

"If you refuse to serve the Lord,
then choose today whom you will serve."
JOSHUA 24:15 NLT

What a wonderful privilege that we get to choose so many things in life! We choose whom we marry, where we live, what church we go to, what outfit we wear. Above all of those things, however, is life's most important choice: choosing to serve the Lord. Today He reaches out with arms of love. Will you respond to that love? It's your choice.

Dress for Success

And over all these virtues put on love,
which binds them all together in perfect unity.

COLOSSIANS 3:14 NIV

Have you ever considered that love is part of your wardrobe? In the same way that you slip on a blouse or a pair of slacks, you can dress yourself in love each day. And adding love to the wardrobe means you're truly dressed for success. It's not always easy. In fact, you have to choose to wear love, much as you would choose your shoes. It's always the right choice!

Let Love Flow!

*"Just as the Father has loved Me, I have
also loved you; abide in My love."*

JOHN 15:9 NASB

We love as we are loved. Think about that
statement for a minute. We tend to share love
to the same degree that we receive it. God
pours out his love to us 24/7. His fountain
of grace, love, and mercy flows freely. And
as long as we continue to drink from that
fountain, we will become a wellspring of life
for others. Abide in Him. Let love flow!

A Moment-to-Moment Choice

*Love is a choice you make
from moment to moment.*
BARBARA DE ANGELIS

Can you hear the ticking of the clock as the
seconds pass by? Blink and another second
is gone! Turn your head for a moment and
you've lost it. In just that amount of time—
a blink of an eye—you can choose to love.
It is a choice, you know. You can choose to
love even the most unlovable person. Don't
let another minute tick by. Choose love.

A Necklace of Love

Let love and faithfulness never leave you;
bind them around your neck, write them on the
tablet of your heart. Then you will win favor
and a good name in the sight of God and man.

PROVERBS 3:3–4 NIV

Have you ever had a really great necklace?
Perhaps a relative or close friend has
passed one down to you. In some ways,
love is like an exquisite necklace, one you
deliberately choose to wear. Each bead or
stone represents one person you've loved
or someone you've forgiven. It encircles
you, reminding you of God's endless love.
And it hangs near your heart, a constant
reminder that He is only a heartbeat away.

Love as He Loves

Because He First Loved Me

We love because he first loved us. Whoever
claims to love God yet hates a brother or
sister is a liar. For whoever does not love
their brother and sister, whom they have seen,
cannot love God, whom they have not seen.
And he has given us this command: Anyone who
loves God must also love their brother and sister.

1 JOHN 4:19–21 NIV

Can you imagine anything more frustrating
to the unbeliever than a Christian who claims
to love God but doesn't extend love—or
mercy, or grace—to others? How hypocritical
that must seem. Those who follow Jesus
Christ are called to share His love, and not
just to people who seemingly deserve it.
Jesus loved the unlovable, and we're called
to do the same. Following wholeheartedly
after God means we must love as He loves.

As I Have Loved You

"A new commandment I give to you, that you love one another, even as I have loved you, that you also love one another."

JOHN 13:34 NASB

Why do you suppose Jesus had to command His followers to love one another? Seems a little sad, doesn't it? You would think that loving others would come naturally. But Jesus realizes we don't always have it in us to offer the same kind of love that He offers. His love is life-changing. Oh, that we could extend life-changing love to the world around us!

A Sweet-Smelling Offering

*Live a life of love just as Christ
loved us and gave himself for us as a
sweet-smelling offering and sacrifice to God.*
EPHESIANS 5:2 NCV

What does it mean to live a life of love?
For some it comes naturally. Others have
to work at it! Living a life of love means
that you pour yourself out like perfume
as a fragrant offering—both to God and to
those around you. Your words taste and
smell sweet. So do your actions. You leave
behind a pleasant aroma, and people long
to be around you. Mmm! Smell that love?

Slow to Anger

*The Lord is compassionate and gracious, slow
to anger, abounding in love. He will not always
accuse, nor will he harbor his anger forever;
he does not treat us as our sins deserve or
repay us according to our iniquities.*

PSALM 103:8–10 NIV

One way to know you're "abounding" in God's
love is to live a life that reflects His character.
When you're slow to anger and refuse to knee-
jerk when provoked, you're demonstrating
His love. God doesn't treat us as we deserve
(thank goodness!), and He expects that we
will offer that same generosity to others,
even when they wrong us. Don't repay evil
for evil. Put the brakes on that anger!

Love's Measurement

Love measures our stature: the more
we love, the bigger we are. There is no
smaller package in all the world than that
of a man all wrapped up in himself.
WILLIAM SLOANE COFFIN JR.

How big is your love? Think about that question for a moment. Do you "love big" or are you someone who holds back, only extending love when you feel it's deserved? When we withhold love, we're telling others that our thoughts and emotions are more important than they are. Love big today! Don't make everything all about you. You'll be surprised at how big you feel when you share God's love with others!

The Real Deal

The Love Proof

Dear children, let us not love with words
or tongue but with actions and in truth.
1 JOHN 3:18 NIV

It's one thing to tell people that you love
them; it's another to live out that love with
your actions. Sure, we say "I love you" all
the time, but do we always follow those
words up with the proof? Slipping up is easy,
especially with people who are difficult to
love. But God is always more interested
in our actions than our words. He desires
for us to love in word—and in deed.

Simple. . .and Difficult

Love one another and you will be happy.
It's as simple and as difficult as that.
MICHAEL LEUNIG

When you were young, you probably never thought of love as being difficult. It was as simple as wrapping your arms around your mother's neck or kissing your father good night. In the grown-up world, you discovered that some people are tough to love. Still, God commands it. Why? To test us? No, He longs for us to experience true joy, which comes only in a life filled with God-breathed love.

Nothing. . .or Everything?

If I speak in the tongues of men and of angels,
but have not love, I am only a resounding
gong or a clanging cymbal. If I have the gift of
prophecy and can fathom all mysteries and all
knowledge, and if I have a faith that can move
mountains, but have not love, I am nothing.
1 CORINTHIANS 13:1–2 NIV

It's one thing to claim to know God and to be
called to a life of service to Him. It's another
thing to back it up by loving the people
He's placed in your life. You don't want to
be a clanging gong (someone who talks the
talk but doesn't walk the walk). Instead, be
known as one who backs up her words with
genuine love and compassion for others.

Forced to Love

Flatter me, and I may not believe you.
Criticize me, and I may not like you. Ignore
me, and I may not forgive you. Encourage
me, and I will not forget you. Love me,
and I may be forced to love you.
WILLIAM ARTHUR WARD

Want to know how to win over even the
toughest person? Win him with your love.
Draw her with your kindness. People don't
respond well to criticism or flattery, but love
will win them every time. Oh, it might take
awhile, especially if they don't trust you. But
in the end, God-ordained love will usually
win over even the toughest of people!

Genuine Love

You must teach people to have genuine love,
as well as a good conscience and true faith.
1 TIMOTHY 1:5 CEV

Isn't it interesting to read that we have to
"teach" people to have genuine love? You
would think it would come naturally! But
genuine love is tougher than it's advertised
to be. Real love is, after all, sacrificial. We
enjoy a kiss on the cheek or a hurried "I
love you" as we're hanging up the phone.
But sacrifice? That's not as easy, is it? Allow
genuine love to lead the way today!

God's Love for Us

His Profound Love

I pray that you, being rooted and established in love, may have power, together with all the Lord's holy people, to grasp how wide and long and high and deep is the love of Christ, and to know this love that surpasses knowledge—that you may be filled to the measure of all the fullness of God.

EPHESIANS 3:17–19 NIV

Have you ever paused to contemplate God's unfathomable love for us? If we could climb to the top of the highest mountain, we couldn't outclimb His love. If we plummeted to the depths, His love would meet us there. If our vision could expand to see beyond the stars, we would find His love waiting there for us. There is truly nothing to compare with the profound love of our Savior!

Shackles of Love

*There's nothing more freeing
than the shackles of love.*
EMMA RACINE DE FLEUR

God never intended that we should live a
life feeling imprisoned by anger, frustration,
or pain. Love overcomes all of those things!
In a manner of speaking, love binds and
shackles us, but we don't feel imprisoned.
Instead, we are set free! For God's love
supersedes even the toughest of challenges
and tears down prison walls. Today make
a choice to replace the negative shackles
in your life with the shackles of love.

Hearts Filled with Love

And this hope will not lead to disappointment.
For we know how dearly God loves us,
because he has given us the Holy Spirit
to fill our hearts with his love.

ROMANS 5:5 NLT

Have you ever doubted God's love for you?
Wondered if He's still there, looking out
for you? One way you can know for sure
that God loves you is to recognize His gift
of the Holy Spirit, who resides inside you.
God sent the Spirit, our Comforter, so that
we would know we're never alone. Talk
about a precious reminder of God's love!

Never Forsaken

For the L{.smallcaps}ORD loves the just and will not forsake his faithful ones. Wrongdoers will be completely destroyed; the offspring of the wicked will perish.

PSALM 37:28 NIV

God loves all of humankind, but it's clear that He has a special place in His heart for those who call Him "Father." He adores those who are faithful to Him and who treat others justly. Unlike some earthly fathers, God never abandons His kids. Never. He will protect us forever. What an amazing heart of love our Daddy God has for us!

Abiding Love

*Whoever confesses that Jesus is the Son of God,
God abides in him, and he in God. So we have
come to know and to believe the love that God
has for us. God is love, and whoever abides in
love abides in God, and God abides in him.*

1 JOHN 4:15-16 ESV

Are you wowed by God's unending love? It's
pretty amazing, isn't it? Once we discover
it—and see that it has no limits—we are awed
by such spectacular love! All we have to do
to receive this love is confess that Jesus is
the Son of God. When we do, the Creator
of heaven and earth sweeps in and abides
in us. Praise the Lord for His abiding love!

Our Love for God

And he said to him, "You shall love the Lord your God with all your heart and with all your soul and with all your mind. This is the great and first commandment."
MATTHEW 22:37–38 ESV

It's one thing to love God with our heart. It's another to love Him with our mind. To love Him with our mind means that He controls our thoughts, which inevitably control our actions. To love God with your mind means your ultimate desire is for His thoughts to be your thoughts. Spend some time focusing on loving God with your thoughts today. The reward will be great!

Because We Love Him

*"Because he loves me," says the L*ORD*,
"I will rescue him; I will protect him,
for he acknowledges my name."*

PSALM 91:14 NIV

Have you fallen in love with the God of the universe? He desires a love relationship with you, you know. He longs for you to come into His presence and to give your heart to Him. When God sees that you've fallen head over heels for Him, He rushes in to become your rescuer and protector. This is love's response—to sweep in and protect. And it's all because you love Him.

Faithful in Love

Love the LORD, all his faithful people!
The Lord preserves those who are true to
him but the proud he pays back in full.

PSALM 31:23 NIV

Being faithful is a natural consequence of loving someone. Because we love our spouse, we're faithful, no matter the temptation. And we stick by our family members, even when we disagree with their actions. We're true to our friends in thick and thin. God wants us to be faithful to Him, as well. No straying. No playing the field. We're His bride, linked by love, faithful until He calls us home to heaven.

Showered with Grace

*May God's grace be eternally upon all
who love our Lord Jesus Christ.*
EPHESIANS 6:24 NLT

Did you know that your love for Jesus
has an amazing return? When you love
Him, God showers you with grace, not
just now, but for eternity. Grace, mercy,
and compassion are yours—all because
you love Him. What a great deal! Praise
the Lord for His love-induced grace!

Loving Equals Giving

*You can give without loving, but you
can never love without giving.*
AUTHOR UNKNOWN

Isn't it interesting to think that God owns
everything? Every star. Every continent. Every
breath we breathe. He owns it all. Our time
on earth is brief and we "own" so little in
comparison with God; but what we do have,
the Lord expects us to share. He wants us to
be givers. When we're in relationship with
others, we give to them—not out of obligation,
but out of love, for loving equals giving.

Ah, Romance!

First Love

How on earth are you ever going to explain in terms of chemistry and physics so important a biological phenomenon as first love?
ALBERT EINSTEIN

Remember that feeling you got in the pit of your stomach the first time you "fell in love"? Felt like a butterfly farm had been set free, didn't it! You couldn't walk straight, talk straight, or think clearly. The only thing you could see was that other person. Most of us have long since forgotten about our first loves, but God has not. From the very beginning, He has been passionately in love with us!

Friendship Caught on Fire

Love is like a friendship caught on fire. In the beginning a flame, very pretty, often hot and fierce, but still only light and flickering. As love grows older, our hearts mature and our love becomes as coals, deep-burning and unquenchable.

BRUCE LEE

Isn't that an interesting quote? The best love relationships are based on strong friendship. When the two of you get along on multiple levels, you move beyond the "goose bumps and tingles" stage and into something more lasting. And how beautiful love looks as you grow old together. It's like a fire well tended, your love burning as deep as unquenchable coals. Oh, to have that kind of love!

Arise, My Love

My beloved spoke and said to me, "Arise, my darling, my beautiful one, and come with me. See! The winter is past; the rains are over and gone. Flowers appear on the earth; the season of singing has come, the cooing of doves is heard in our land. The fig tree forms its early fruit; the blossoming vines spread their fragrance. Arise, come, my darling; my beautiful one, come with me."

SONG OF SONGS 2:10–13 NIV

There's something rather magical about finding real love. You know when it's right. If you've experienced a proposal of marriage, then you know what it's like to have that person extend a "Come away with me, my darling, my beautiful one," moment. Nothing in the earthly realm can top it. If you haven't experienced it, don't fret! God whispers those same words in your ear, even now. "Arise, My darling!"

For the Rest of My Life

When you realize you want to spend the rest of your life with somebody, you want the rest of your life to start as soon as possible.
NORA EPHRON, *WHEN HARRY MET SALLY*

Oh, what bliss, to discover the person you're supposed to marry! God designed men and women to love for a lifetime. And once you realize you've found "Mr. Right" (or Ms. Right), you're ready to jump in headfirst. This same kind of enthusiastic love was evidenced to us through the life of Jesus, who rushed headlong toward the cross. There He demonstrated a love that would never end.

His Banner over Me Is Love

"He has brought me to his banquet hall,
and his banner over me is love."
SONG OF SOLOMON 2:4 NASB

Remember the song from childhood: "His banner over me is love!" The only love that comes close in this lifetime is the love found between a husband and wife. When the two are joined as one, you enter a "banquet hall," where two become one in every sense of the word. There, in that intimate place, you share all of life's joys and sorrows—together.

Loving Your Spouse

As You Love Yourself

Each one of you also must love his wife as he loves himself, and the wife must respect her husband.

EPHESIANS 5:33 NIV

Husbands are taught by scripture to love their wives as they love themselves. There's nothing more motivating to a wife than the genuine love of a godly husband, one who would be willing to lay down his life for her. It propels her to be the best possible wife she can be. Respect comes easy for a man who loves like that!

Love's Progression

Love seems the swiftest, but it is the slowest of all growths. No man or woman really knows what perfect love is until they have been married a quarter of a century.

MARK TWAIN

Ah, those first few years of marriage. We're blissfully, blindly in love. We can't see each other's flaws. But the passage of time brings everything to light, doesn't it? Our love shifts and progresses to something different altogether. No longer is it just about the "ooey, gooey" kind of love. Mature love now sees the flaws of the other person—but loves anyway. Now, that's real love!

Incomprehensible Love

There are three things that amaze me—no,
four things that I don't understand: how an
eagle glides through the sky, how a snake
slithers on a rock, how a ship navigates
the ocean, how a man loves a woman.
PROVERBS 30:18-19 NLT

The love between a man and woman is a
wondrous thing. It's God-breathed. When two
people are in love, they can't see straight.
Nothing else exists! God designed us to share
this amazing, toe-tapping, heart-singing love.
It's inexplicable and often defies reason, but
that's the beauty of it. Some things just aren't
meant to be understood—just experienced.

She Who Loves
Her Husband. . .

*Then they can urge the younger women
to love their husbands and children.*
TITUS 2:4 NIV

In biblical times, young women often married
older men, and not usually for love. They
were betrothed based on selections made
by the father. No wonder they would have
to "train" to love their husbands! Love would
grow over time after the couple took their
vows. Things are different today, but we
all still need time to mature in our love.
Real love continues to grow over time.

Gazing the Same Direction

Love does not consist of gazing at each other,
but in looking together in the same direction.
ANTOINE DE SAINT-EXUPERY

When you're in love with someone, you often
find yourself staring into each other's eyes. Ah,
love! It's so romantic. People who've been in
love for many years, however, learn that it's far
more important to gaze in the same direction—
toward the Lord. Keeping our eyes on Him will
keep the romance fresh and the direction sure.

Loving Your Family

Morning Dew

Love is like dew that falls
on both nettles and lilies.
SWEDISH PROVERB

Not every person is easy to love, even within
our families. There's usually at least one
member of the clan who presents an ongoing
challenge. Here's the good news: God's love
really does rain down on those who are easy to
love—and on those who aren't. And because
we recognize that He loves everyone, we can
open our hearts to love them too—easy or not.

Love in the House

*Better a small serving of vegetables with
love than a fattened calf with hatred.*
PROVERBS 15:17 NIV

We often think that material possessions
can buy happiness. Nothing is further from
the truth. What good would it serve if you
had everything but couldn't get along with
the people in your own household? How
sad that would be. It would be better to
toss the fancy car and expensive house
and learn to love your family the way God
loves them. It might be challenging, but the
end result would make it all worthwhile.

Love for Children

*Before becoming a mother I had a hundred
theories on how to bring up children. Now I have
seven children and only one theory: Love them,
especially when they least deserve to be loved.*
KATE SAMPERI

Remember the first time you gazed down into
the face of your baby? Oh the feelings of love
that swept over you. Then that little darling
turned two and learned the word *no*. Suddenly
love got mixed up with discipline and you found
yourself a little short-tempered. Loving your
child is easy—most of the time. But even in the
challenging moments, remember that we're
God's kids, and His love for us never ceases!

Saved by Love

By faith Noah, when warned about things not yet seen, in holy fear built an ark to save his family. By his faith he condemned the world and became heir of the righteousness that is in keeping with faith.
HEBREWS 11:7 NIV

There's a great story in the Bible about Noah—a righteous man chosen by God to save humankind by building an ark. Noah and his family climbed aboard the monstrous boat and escaped the floodwaters. Why did God choose Noah? Because he was a righteous man. Humankind was saved by God's love, not just on the ark, but when God sent His Son, Jesus, to rescue us from sin.

The Need for Love

*A baby is born with a need to be
loved—and never outgrows it.*
FRANK A. CLARK

Ever wondered what your child needs? A new
toy? The latest, greatest video game? A fancy
house? The best school? Perfect parents? No,
the one thing your child needs above all is love.
That's it, plain and simple. When they're good,
and when they misbehave, our children need
to see consistent, God-breathed love—from
their parents, grandparents, teachers, and
friends. Spend time loving a child today. You
won't regret it, and neither will the child!

Loving Your Neighbor

Sum It Up!

The commandments, "You shall not commit adultery," "You shall not murder," "You shall not steal," "You shall not covet," and whatever other commandment there may be, are summed up in this one command: "Love your neighbor as yourself." Love does no harm to a neighbor. Therefore love is the fulfillment of the law.
ROMANS 13:9–10 NIV

"Love your neighbor as yourself." We've heard these familiar words all of our lives, but what do they mean? And, who is our neighbor? The guy in the house next door? The woman at the grocery store? Our neighbors are those people we see day in and day out. God desires that we love them in the very same way we love ourselves. Today ask the Lord to show you how to love your neighbors.

Around the Clock Love

A friend loves at all times, and a brother
is born for a time of adversity.

PROVERBS 17:17 NIV

Have you ever considered the idea that a friend loves at all times? Seems impossible, doesn't it? Even friends squabble. They don't get along from time to time. They might even part ways. Still, God longs for the love to remain intact. Today if you're in a rough season with a friend, ask the Lord to restore your love. Then be ready to be that person's friend—24/7.

Brotherly Affection

Let love be genuine. Abhor what is evil; hold fast to what is good. Love one another with brotherly affection. Outdo one another in showing honor.
ROMANS 12:9–10 ESV

Brotherly affection is that "slap on the back," "laugh at the same jokes" kind of love. Affection means caring. When you love, you genuinely care about other people—how they feel, their hopes and dreams, their heartbreaks. Everything about them matters to you because it matters to them. Hold fast to what is good. Love one another!

Love Your Brother

We love because he first loved us. Whoever claims to love God yet hates a brother or sister is a liar. For whoever does not love their brother and sister, whom they have seen, cannot love God, whom they have not seen. And he has given us this command: Anyone who loves God must also love their brother and sister.

1 JOHN 4:20–21 NIV

It's interesting to think that we're commanded to love God even though we have never seen Him with our eyes. Stranger still is that we have a hard time loving our brother—friend, neighbor, fellow church member—whom we *have* seen. God's ideal arrangement includes loving both the one we can see and the One we can't.

Plural Love

Love is not singular except in syllable.
MARVIN TAYLOR

Love is plural. It's not an "I, me, my" thing. It's meant to be shared among two or more parties. Whether you share it with a spouse, parent, child, neighbor, or friend at church, when you give love, you receive love. When you share it, you double your portion. And when you love others, you receive love in response. Thank God for love's plurality!

Loving Your Enemies

Love Your Enemies

"But I say, love your enemies!
Pray for those who persecute you!"
MATTHEW 5:44 NLT

We're not just called to love people who love
us; we're commanded to love the ones who
hurt us—the very ones who bring us grief. How
is that possible? First, we have to acknowledge
that all of us sin and fall short of the glory
of God. Next, we have to let go of any
bitterness and pain. Finally, we must pray for
our enemies. Only in prayer can love win out.

The Love Test

If your enemy is hungry, give him bread to
eat, and if he is thirsty, give him water to
drink, for you will heap burning coals on
his head, and the LORD will reward you.
PROVERBS 25:21–22 ESV

What would you do if your mortal enemy
was in trouble? Say, his house burned down
or his child was critically ill? Would you pass
the love test? Could you lay your angst aside
and extend a hand in his direction, genuinely
offering love? Spend some time today asking
the Lord to share His plan for sharing love
with those who have become enemies. Before
long, the walls will come tumbling down!

A Directed Heart

*May the Lord direct your hearts into the love
of God and into the steadfastness of Christ.*

2 THESSALONIANS 3:5 NASB

God longs for us to be directed, not
by emotion, but by His love and the
steadfastness of His Son. When we allow
our hearts to be directed by God's amazing
love, we really can deal with our enemies
in a godly way. We have to slow down, take
a deep breath, and listen for God's voice.
Only then can we sense His direction and
respond with His love leading the way.

Love. . .and Do Good

*"But to you who are listening I say: Love your
enemies, do good to those who hate you."*
LUKE 6:27 NIV

Love is always followed by actions. And not
just any actions either. When we genuinely
love someone, we will respond to him with
kindness. We'll treat him right, even if he
doesn't respond similarly. Love always goes
hand in hand with "doing good." Sure, it's
hard at times, but God will give you the
strength to get through, so dive in! Loving
others with your actions is the way to go!

Transformed by Love

Love is the only force capable of transforming an enemy into friend.
MARTIN LUTHER KING JR.

Love is a powerful force, bringing mortal enemies together and restoring near-impossible relationships. Think of someone you've fallen out of relationship with. Take the time to pray for him or her. Ask the Lord to show you how to love that person so that the relationship can be restored if at all possible. Then sit back and wait for the transformation to take place!

Love for Your Fellow Believers

Love for the Church

*We know that we have passed out of death
into life, because we love the brothers.
Whoever does not love abides in death.*

1 JOHN 3:14 ESV

Our brothers and sisters in Christ should be
like family members to us. And like family
members, they're not always easy to love!
But loving fellow church members is the
best way to show that we love God. If we
love Him, we should love His kids. This is
how we know that we are alive in Christ.

Love's Meditation

Within your temple, O God,
we meditate on your unfailing love.

PSALM 48:9 NIV

Don't you just love corporate worship? There's
something about lifting your voice, your hands,
and your heart to the King of kings and Lord
of lords in the midst of fellow believers. And
what an awesome time to meditate on God's
unfailing love. As one body, one unit, we come
together and recognize the very love that binds
us. How wonderful to dwell together—in love!

Loving His People

God is always fair. He will remember how you helped his people in the past and how you are still helping them. You belong to God, and he won't forget the love you have shown his people.
HEBREWS 6:10 CEV

God is watching to see how we treat fellow believers. He's looking down from His throne in heaven, making sure we're bound together by His love. When we love, we extend a hand of kindness and friendship. No, it's not always easy, but it's God's way. And isn't it interesting to read that God won't forget how we've helped His people? His long-term memory is wonderful!

Brothers and Sisters

*Respect everyone, and love the family of
believers. Fear God, and respect the king.*
1 PETER 2:17 NLT

Families have squabbles even under the best of
circumstances. The same holds true in the body
of Christ. We're one big happy family with God
as our Father, but sometimes we disagree. We
even argue. Loving someone doesn't mean
you'll always see eye to eye, but it does mean
you respect the other person and treat him or
her with dignity. Now, that's God's kind of love!

Supreme Happiness

*The supreme happiness of life is the conviction
that we are loved—loved for ourselves,
or rather, loved in spite of ourselves.*
VICTOR HUGO

Stumbling through life without love would
be so difficult. There's nothing better than
realizing you're loved simply because you're
you. You don't have to do anything to earn
it. You're simply loved. Doesn't that make
your heart want to sing? God loves us in
spite of ourselves! Praise Him for that!

Responding to Your Coworkers in Love

Built Up by Love

But knowledge puffs up while love builds up.
1 CORINTHIANS 8:1 NIV

If you're active in the workforce, then
you know how tough it can be to love
your fellow workers. More often than
not, we're out to prove that we're better
than the next person, not to shower that
person with love. However, sharing God's
love with others at our workplace is really
God's plan for us. Make a decision today to
build up your coworkers by loving them.

What the World Needs

What the world really needs is
more love and less paperwork.
PEARL BAILEY

Ah, the office! Sometimes chaos reigns. The
workload is high, stresses are even higher,
and emotions rule the day. In the midst
of the deadline-infused madness, we're
expected to love our coworkers, not just in
word, but also in deed. Seem impossible?
It's not. We need to stop long enough to
take a deep breath and focus. With God's
help, even the madness is manageable, as
long as we allow His love to lead the way.

Our Pursuit

Whoever pursues righteousness and love finds life, prosperity and honor
PROVERBS 21:21 NIV

Want to be respected in the workplace? Want to garner the right attention from coworkers and the boss? Try righteousness and love. Stand up for what's right. If you pursue righteousness (even when others around you are succumbing to temptation), and if you genuinely love your fellow workers, you will come out a winner in the end. No, the road won't always be easy, but it will be worth it.

Loved Back

Love life and life will love you back.
Love people and they will love you back.
ARTHUR RUBINSTEIN

In the workplace, we often see the best
and the worst in people. Some are almost
impossible to get along with. We pour out
love, and they don't respond. We try again and
receive nothing. We cry out, "How can I love
this person? I don't even like him!" If you're
dealing with a "tough case," don't give up. Keep
extending love. The payoff may be delayed, but
you will be found faithful in the meantime.

A Growing Love

Dear brothers and sisters, we can't help but thank
God for you, because your faith is flourishing
and your love for one another is growing.
2 THESSALONIANS 1:3 NLT

Sometimes office relationships can wane
over time. Maybe you start out as friends,
but the stresses of the environment cause a
deterioration in the friendship. If you want
to maintain great interoffice friendships
that grow even stronger with time, you have
to keep brotherly love in the forefront. It
won't always be easy, but it will be worth it.

Love for the Nations

Good News for the Nations!

*This same Good News that came to
you is going out all over the world. It is
bearing fruit everywhere by changing
lives, just as it changed your lives from the
day you first heard and understood the
truth about God's wonderful grace.*

COLOSSIANS 1:6 NLT

The word *gospel* means good news. We have
good news for the nations! Jesus Christ
came and gave His life for all! If you had
great news that affected your children or
friends, wouldn't you share it? Of course you
would. The same holds true with the nations.
When we develop a love for the nations (and
this is God's heart for us all as believers),
we can't help but share the good news.

Hope for the Nations

In his name the nations will put their hope.
MATTHEW 12:21 NIV

Hope. What a wonderful, precious commodity.
When we have hope, we can face today—
and tomorrow. And when we have a love
for God's people across the planet, even
in places where we've never been, we long
to offer them hope, as well. But who will
share the Good News? We're all called to
participate! Through our giving, our "going,"
and our great love, the gospel will be spread.

Disciple the Nations

Therefore go and make disciples of all nations,
baptizing them in the name of the Father
and of the Son and of the Holy Spirit.
MATTHEW 28:19 NIV

To truly disciple people, we have to love
them. Otherwise, we won't go the distance
with them. It's a day-in, day-out process
that can be grueling. We're commanded by
Jesus to go and make disciples of all nations—
not converts, but disciples. Love compels
us to go the distance by offering financial
support to missionaries or by making the
commitment to go ourselves. Today pray about
the role you play in reaching the nations.

Every Knee Will Bow

*It is written: " 'As surely as I live,' says
the Lord, 'every knee will bow before me;
every tongue will acknowledge God.' "*

ROMANS 14:11 NIV

Can you imagine what it will be like on that
day when every knee bows and every tongue
confesses that Jesus Christ is Lord? Oh, what
joy that will be! May our love for God and our
love for His people motivate us to reach the
unreached people groups of the world. Every
day we're one step closer to that glorious day!

The Hunger for Love

The hunger for love is much more difficult
to remove than the hunger for bread.
MOTHER TERESA

Don't you love that quote by Mother Teresa?
She's right. People all over the world crave
love. Many don't even realize that's what
they're longing for. We have the love they
need. By sharing Christ, we're passing on
the greatest gift of all—His redemptive love.
And when we extend a hand—with food,
fellowship, compassion, and prayer—we're
adding our love to His. We have the power
to quench the world's spiritual hunger.

Love as a Witness

By This All People Will Know

"A new commandment I give to you, that you love one another: just as I have loved you, you also are to love one another. By this all people will know that you are my disciples, if you have love for one another."

JOHN 13:34–35 ESV

The Bible says that people will know we're God's kids by our love. Love itself is our greatest witness. It's even more important than sharing the gospel or laying out the four spiritual laws. Those things are important, but love is still the key. We back up our words with our actions. And when we love others—truly love them—our words are much more palatable.

Singing of His Love

I will sing of the LORD's great love forever;
with my mouth I will make your faithfulness
known through all generations. I will declare
that your love stands firm forever, that you
established your faithfulness in heaven itself.

PSALM 89:1-2 NIV

When you're filled with the love of the Lord,
it's hard to contain the song that rises up in
your heart. Why stop it? Let it flow! Praise
makes even the hardest situation manageable.
And what a great witness! When others hear
you humming, when they see your passion
for praise, they will wonder what you have
that they don't. Join in the great love song of
all time today—praise to the King of kings!

The Ways to Love

I truly feel that there are as many ways of loving as there are people in the world and as there are days in the lives of those people.
MARY S. CALDERONE

We all have different love languages, don't we? For some, giving of one's time is the most important thing. For others it's gift giving. Some respond well to acts of service, and still others to words of encouragement and praise. If you're trying to witness to a friend or neighbor, take the time to learn that person's love language first. Then love that person as she or he needs to be loved.

Directed by Love

*May the Lord direct your hearts into the love
of God and into the steadfastness of Christ.*
2 THESSALONIANS 3:5 NASB

It's interesting to read that God occasionally
needs to direct our hearts into His love.
Think about how you steer a car. The
steering wheel needs a little nudge to the
right or the left. That's how it is with love
too. If we don't willingly accept God's little
nudges, our love for others can grow cold.
Keep your witness strong by allowing the
Lord to direct your heart as He sees fit.

The One I Love

"Here is my servant whom I have chosen, the one I love, in whom I delight; I will put my Spirit on him, and he will proclaim justice to the nations."

MATTHEW 12:18 NIV

It's easier to be a good witness when we realize that God has given us His Spirit. It also helps to know that we're loved whether we mess up or not. And we do mess up, don't we! We set out to share God's love with a friend and end up in an argument with her instead. Ugh! Still, God loves us, and His Spirit gives us the courage to go out and try again.

Giving Out of Love

Loving Those in Need

*If anyone has material possessions and sees a
brother or sister in need but has no pity on them,
how can the love of God be in that person?*

1 JOHN 3:17 NIV

If we love God, we need to take care of others
even if it means reaching into our wallet to
do it. Material possessions are meant to be
shared. They're a tool for ministering to others.
People see our love when we take pity on
them in their need. And when we give, our
hearts are exposed. Love comes pouring out.

A Fragrant Offering

*Christ loved us and gave himself up for us as
a fragrant offering and sacrifice to God.*
EPHESIANS 5:2 NIV

If we ever want to know how to give, all we
have to do is follow God's example. He gave
His only Son so that we would have life.
Talk about a fragrant love offering! Giving
is sacrificial, which means it isn't always
pleasant. We have to remember that giving
isn't about us. It's about our love for God and
His people. Love is a great motivator to give.

Giving Thanks

*" 'There will be heard once more the sounds of joy
and gladness, the voices of bride and bridegroom,
and the voices of those who bring thank offerings
to the house of the L*ORD*, saying, "Give thanks to
the Lord Almighty, for the Lord is good; his love
endures forever." For I will restore the fortunes
of the land as they were before,' says the Lord."*

JEREMIAH 33:10–11 NIV

One of the ways we "give" is to give thanks to
the Lord. How easy it is to forget to thank Him
for His many blessings. When we see His love
for us, when we realize that He's never going
to leave us or forsake us, we're motivated to
give thanks. And as we lift our voices in praise,
others are watching. We're teaching them
to offer words of thanks to God, as well!

Excel in Giving

But since you excel in everything—
in faith, in speech, in knowledge, in
complete earnestness and in the love
we have kindled in you—see that you
also excel in this grace of giving.
2 CORINTHIANS 8:7 NIV

We want to excel at everything we do,
and that takes effort on our part. So we
work to have excellent parenting skills. An
excellent work ethic. Excellent financial
prowess. But what about giving? If we love
God and others, we should strive to become
excellent givers. Want to excel today?
Consider giving of yourself to others.

Never Wasted

Love and kindness are never wasted. They always make a difference. They bless the one who receives them, and they bless you, the giver.
BARBARA DE ANGELIS

We don't give to get. Still, there's no denying that love is reciprocal. It has a boomerang effect. It's never wasted. What goes around comes around. Even if you're setting out to be a blesser, you'll end up being blessed in the end. And when you reach deep to give, the blessing can far outweigh the sacrifice.

Love and Praise

Unquenchable Love

Many waters cannot quench love; rivers cannot sweep it away. If one were to give all the wealth of one's house for love, it would be utterly scorned.
SONG OF SONGS 8:7 NIV

Have you ever been so thirsty that a cup of water didn't satisfy you? If so, then you have some understanding of how love works. The more you have of it, the more you want. And God's love for us is so overpowering that nothing we do can wash it away. Talk about amazing love! Lift up your voice in praise for the love you've been shown.

Awaken to Love

But I will sing of your strength, in the morning I will sing of your love; for you are my fortress, my refuge in times of trouble.

PSALM 59:16 NIV

Oh, the love of God! It's such a wonderful gift, pouring down from the throne of God. Realizing His great love for us is overwhelming. We can't help but praise! We find ourselves awakening in the morning with songs of worship on our lips, thanking God for all He's done for us. What an awesome way to start the day.

His Love Toward Us

For great is his love toward us,
and the faithfulness of the LORD
endures forever. Praise the Lord.

PSALM 117:2 NIV

We'll never be able to understand God's love toward us. It extends grace when grace is the last thing we deserve. It offers forgiveness when we've committed the most heinous of sins. It reaches out to us when we're haughty and proud and comes looking for us when we've sunk to the lowest low. Doesn't that kind of love make you feel like shouting? Like praising God at the top of your voice?

I Will Bow Down

I will bow down toward your holy temple and
will praise your name for your unfailing love and
your faithfulness, for you have so exalted your
solemn decree above that is surpasses your fame.

PSALM 138:2 NIV

Sometimes we come into God's presence
and we feel like shouting for joy. At other
times, His love drives us to our knees. Oh,
how we're humbled by what He has done
for us. We kneel in His presence and praise
His name, not just for His gifts, but also
for His moment-by-moment offering of
love. Our God is worthy to be praised!

A Poetic Heart

Poetry spills from the cracks of a broken heart, but flows from one which is loved.
CHRISTOPHER PAUL RUBERO

When we're broken and bruised, we turn inward. The pain leaks from the cracks like a melancholy dirge. But when we're aware of God's goodness toward us—His love, His grace, His mercy—a different sort of song erupts. We're overcome with a melody of praise!

Rejoicing in Love

Rejoice in His Love!

I will be glad and rejoice in your love, for you saw my affliction and knew the anguish of my soul.

PSALM 31:7 NIV

Are you one of those people who loves to praise God? Do you enjoy lifting your heart and voice to Him in glorious song for all He's done? The Lord loves it when His children offer a sacrifice of praise. And why not? His love provokes us to exalt Him. When we think about it, when we come to fully understand it, how can we do anything but praise?

Give Thanks to the Lord

After consulting the people, Jehoshaphat
appointed men to sing to the LORD and to praise
him for the splendor of his holiness as they
went out at the head of the army, saying: "Give
thanks to the Lord, for his love endures forever."

2 CHRONICLES 20:21 NIV

Don't you love early mornings? They're
filled with promise. New day. New dawn.
New chance to experience God's awesome
love. He is pleased when we make a choice
to give thanks early in the day. His enduring
love never sleeps, so it meets us fresh every
morning. Praise Him for that unfailing love,
even before your eyes are fully open!

Sing for Joy

But let all who take refuge in you be glad;
let them ever sing for joy. Spread your
protection over them, that those who
love your name may rejoice in you.
PSALM 5:11 NIV

There are so many things to rejoice over when you're in love with the Creator of heaven and earth, and rejoicing changes your perspective on everything! Remember that little song you used to sing as a child: "I've got the joy, joy, joy, joy down in my heart!" It's true. Love gives birth to joy. And when that joy spills over, watch out! It's contagious!

Those Who Love Salvation

*But may all who seek you rejoice and be glad
in you; may those who long for your saving
help always say, "The LORD is great!"*

PSALM 40:16 NIV

When you think about what Jesus did on the
cross for you, how does it make you feel?
Overwhelmed? Grateful? Filled with joy? The
free gift of salvation gives us all the reason we
could ever need to lift our voices in praise to
God. There on Calvary, He poured out His love
for humankind. And now we have the glorious
privilege of pouring out our praise in response.

God's Finger

There is no surprise more magical than the surprise of being loved. It is God's finger on man's shoulder.
CHARLES MORGAN

Have you ever had a surprise birthday party? Maybe the guests caught you off guard with the surprise celebration. God's love is a lot like that. When we least suspect it. . .surprise! He showers us with His love. When we're feeling as if we're completely unlovable. . .surprise! There He goes again, loving us unconditionally. Talk about a reason to praise!

Loving in
Hard Times

Knowing God

*Whoever does not love does not
know God, because God is love.*
1 JOHN 4:8 NIV

Love isn't always easy, is it? Sometimes it's
tough to extend love, particularly when our
feelings are hurt or we're wounded in some
way. The Bible is clear that God is love. He
epitomizes it, in fact. And if we withhold our
love from others, even if we feel justified,
we break God's heart. If we claim to know
Him, we have no choice but to love.

The Ride

Love doesn't make the world go 'round;
love is what makes the ride worthwhile.
FRANKLIN P. JONES

Likely you've heard the old expression: "Love makes the world go 'round." Truthfully, God makes the world go 'round, but He is love, after all! His love is the driving force in our lives, and it certainly encourages us to keep going, even when we don't feel like loving others. The next time you think you can't hang on for the ride, remember that God's love is strong enough to cover all the rocky places.

Love's Vision

Love is not blind—it sees more, not less. But because it sees more, it is willing to see less.
JULINS GORDON

When we walk in God's love, we have the power to see—and to overlook. Overlook what, you ask? Flaws in others. Slipups from those who make mistakes. Careless words spoken to us by others. When we love someone—*truly* love someone—we're able to see past the mess-ups and offer forgiveness. That's what it means to have God's vision.

Supported by Love

When I said, "My foot is slipping,"
your unfailing love, LORD, supported me.
When anxiety was great within me,
your consolation brought me joy.

PSALM 94:18–19 NIV

Do you ever feel like slipping when you're
around an unlovable person? To say the wrong
thing? To let the other person have it? Some
people really are harder to love than others,
but God's brand of love guards itself against
the slippery slope of anger. Next time you feel
like snapping, ask the Lord for His perspective.
He can refill your love tank in a hurry!

Because of His Great Love

But because of his great love for us, God, who
is rich in mercy, made us alive with Christ
even when we were dead in transgressions—
it is by grace you have been saved.

EPHESIANS 2:4–5 NIV

Sometimes we just don't feel like loving. We
not only withhold love, but we punish others
by not forgiving them for what they have done
to us. This brings a rift in our relationships,
and it isn't good for us. Love acts as a buffer.
God extended mercy to us. Why? Because of
His great love. We must love, even in the hard
times, so that mercy and grace can follow.

The Love Pursuit

Chasing after Love

Whoever pursues righteousness and
love finds life, prosperity and honor.
PROVERBS 21:21 NIV

Sometimes love comes easily, and at other
times we have to pursue it. Chase after
it. Catch up to it. When we pursue the
Lord with our whole heart, He will give us
the ability to love even the most difficult
people. That's the kind of compassion He
showed us, after all. He pursued us all the
way to the cross. Talk about a love pursuit!

Follow Hard after God

Take me away with you—let us hurry!
Let the king bring me into his chambers.
SONG OF SONGS 1:4 NIV

Have you ever heard the expression "follow hard after God"? To follow Him with passion means that you can't live without Him. This kind of passionate love between God and His people has been going on since the beginning of time. He longs for you to run into His arms so that His love can bring healing in your life. Hurry into His chambers today! There He awaits with arms extended.

Search and Find

*"I love all who love me. Those who
search will surely find me."*
PROVERBS 8:17 NLT

Isn't it wonderful to know that our love for
God is always reciprocated? We express love.
He returns it—and then some. Not so with
humans! But God has the ability to return our
love with interest! We could never outgive
Him, no matter how hard we tried. If you're
on a search for love, turn to the One who
knows it best—and expresses it most.

Overflowing Love

*And may the Lord make your love for one
another and for all people grow and overflow,
just as our love for you overflows.*

1 THESSALONIANS 3:12 NLT

Overfilling a glass can be messy; overfilling
your love tank is anything but! God wants us
to have overflowing love—for him, for our
fellow believers, and even for those who
annoy us. If you ask, the Lord will increase
your love for others. Before long, you'll be
spilling all over everyone—those you're closest
to and those who drive you a little crazy!

Tend the Fire of Love

*Love is like a campfire: It may be sparked
quickly, and at first the kindling throws
out a lot of heat, but it burns out quickly.
For long-lasting, steady warmth (with
delightful bursts of intense heat from time
to time), you must carefully tend the fire.*

MOLLEEN MATSUMURA

Part of the love pursuit is stirring the embers.
We can't allow love to grow stagnant. Keeping
it aflame requires work on our part. Think about
the various love relationships in your life today.
Your relationship with the Lord. Your love for
family members, friends, and coworkers. Do
any of those relationships need a good stirring?
If so, get busy! Don't let that love-fire go out!

Love Lights
the Way

The Most Excellent Way

And yet I will show you the most excellent
way. If I speak in the tongues of men or
of angels, but have not love, I am only a
resounding gong or a clanging cymbal.
1 CORINTHIANS 12:31–13:1 NIV

If you've ever navigated a rocky path in
the dark without a flashlight, you have
some small taste of what it would be like
to go through life without love. You could
probably make it from point A to point B,
but what a rough trip! In the scripture above,
God shows us the most excellent way to
make the journey. Let love light the way!

Guiding Light, Guiding Love

Love is not consolation. It is light.
FRIEDRICH NIETZSCHE

Don't you love the story of the wise men
who followed the star to locate baby Jesus?
The light guided them. Love is a lot like that.
When it's burning brightly—and that's how
God intended it to be—our vision is much
clearer. We can see where we're going. It lights
our path and guides us to our destination.

The Love Light

Love must be as much a light as it is a flame.
HENRY DAVID THOREAU

Love brings warmth and comfort. It's like a warm, cozy blanket on a cold day. But love is as much a light as a flame. It's not just meant to make us feel good; it sparks in our innermost being and drives us to be better. To care more. To share more. Love points the way in every relationship, good and bad.

Faith, Hope, and Love

Love never fails. . . . And now these three remain: faith, hope and love. But the greatest of these is love.
1 CORINTHIANS 13:8, 13 NIV

When everything else fades away to nothingness, love will remain. Think about that for a moment. When this earth as we know it is long gone, God's love for us will remain. All of our possessions, talents, and abilities will fade, but the way we treated others—the love we showed them—will linger forever in their memories. Love people in such a way that they will remember you long after you're gone.

Never a Waste

Loving is never a waste of time.
ASTRID ALAUDA

We waste a lot of time doing things that are frivolous. Video games, television, surfing the Internet, bickering with loved ones—these are all ways we fritter away the hours. Thankfully, loving others is never a waste of time. And what a great reflection of God! We illuminate the pathway for our children, friends, and other loved ones when we spend our days loving them.

The Love Debt

The Debt of Love

*Let no debt remain outstanding, except
the continuing debt to love one another,
for whoever loves others has fulfilled the law.*

ROMANS 13:8 NIV

If you've ever taken out a loan for a car
or house, you know the woes of being
indebted to someone else. It's not a great
feeling, is it? There is one debt, however,
that isn't hard to carry. It's the debt of love.
Anger and strife can destroy relationships,
but when the debt of love is paid, hearts
are mended and pain is vanquished. May
your only debt be the debt of love!

Just Enough. . .to Love

We have just enough religion to make us hate,
but not enough to make us love one another.
JONATHAN SWIFT

Throughout history, the church has struggled
with the issue of love. Believers want
unbelievers to line up and walk straight.
To obey the commandments. To follow
the letter of the law. Sometimes, though,
we forget that extending love is the only
way to win people to the Lord. May we
forever be indebted to love, for it has the
capacity to change hearts and lives.

Feed My Lambs

When they had finished eating, Jesus
said to Simon Peter, "Simon son of John,
do you truly love me more than these?"
"Yes, Lord," he said, "you know that I love
you." Jesus said, "Feed my lambs."
JOHN 21:15 NIV

What an earthshaking question Jesus asked
Peter, His beloved disciple. "Peter, do you
love Me more than these?" How would you
answer that question? Surely you would cry
out, as Peter did, "Yes, Lord! You know I do!"
But Jesus' response to His followers will
always be the same: "If you love Me, care
for My children." We're forever indebted
to love others in the body of Christ.

146

Happiness

*To love is to place our happiness
in the happiness of another.*
G. W. VON LEIBNITZ

We all want to be happy. In fact, most of us
feel like we're "owed" happiness. True love,
however, seeks the happiness of the other
person. In some ways, we're indebted to the
other person's well-being. That's God's way.
We are to love others as we love ourselves.
It's not always easy, but extending this kind
of love has great benefits, for what goes
around, comes around. Seek happiness
for others, and you will receive it too!

A Loving Proclamation

*"Therefore, my friends, I want
you to know that through Jesus the
forgiveness of sins is proclaimed to you."*
ACTS 13:38 NIV

Through Jesus, God offers forgiveness of
sins. Think about that for a minute. He has
indebted Himself to humankind through
Jesus' work on the cross. He paid the debt
for our sin! In doing so, God has made a
covenant with us: "Love My Son. Accept His
free gift of salvation. In exchange, I will offer
you forgiveness of sins and eternal life." Oh,
what a gift! What a debt of love He paid!

Love of Life

A thief comes only to rob, kill,
and destroy. I came so that everyone
would have life, and have it in its fullest.
JOHN 10:10 CEV

Don't you just love life? It's filled with
unexpected and undeserved joys. Sure, not
every day is a piece of cake, but we're alive
and well today and have hope for tomorrow.
God's love for us is so deep that He came to
earth so that we could have life. . .and not just
any life. He wants us to have abundant life.
That's a "more than I could ask or think" life.

Renewed by Love

I love people. I love my family, my children. . .but inside myself is a place where I live all alone, and that's where you renew your springs that never dry up.
PEARL S. BUCK

Where do you go to get renewed? To get your love tank refilled? Sometimes we have to escape the chaos—even the good chaos—to find a place of quiet and rest inside ourselves. We have to seek God in the secret places so that we can be renewed by His love. Otherwise, there won't be much inside of us to give out.

Loving Life!

Does anyone want to live a life
that is long and prosperous?
Then keep your tongue from speaking
evil and your lips from telling lies!
PSALM 34:12–13 NLT

How blessed we are to be alive during
the twenty-first century! We have much
available to us and many things to enjoy. If
you want to go on enjoying life for years to
come, then spend your time loving others.
Guard your tongue and treat people as you
would like to be treated. Be honest in all
you do. Your passion for life will increase
as you speak words of love over others.

A Life of Devotion

The way you get meaning into your life is to devote yourself to loving others, devote yourself to your community around you, and devote yourself to creating something that gives you purpose and meaning.

MITCH ALBOM

If you're losing your enthusiasm or feeling down in the dumps, there's a surefire way to add excitement to your life. Love others. Devote yourself to them. Get outside of your "bubble" and focus on those around you in your community or church. Loving others will help you define your purpose and will reignite your passion for life!

Crowned with Love

Praise the LORD, O my soul, and forget not all his benefits—who forgives all your sins and heals all your diseases, who redeems your life from the pit and crowns you with love and compassion.

PSALM 103:2–4 NIV

We take many things for granted in this life: our health, God's provision, our daily bread, the love of family members and friends, and much more. Oh may we never forget to praise our loving God, who showers us with benefits. He forgives our sins. He redeems us from the pit. And He places a glittering crown of love and compassion on us, calling us His daughters and sons.

Ever-Abounding Love

Abounding. . .
More and More!

And it is my prayer that your love may abound more and more, with knowledge and all discernment, so that you may approve what is excellent, and so be pure and blameless for the day of Christ, filled with the fruit of righteousness that comes through Jesus Christ, to the glory and praise of God.

PHILIPPIANS 1:9–11 ESV

Have you ever watched a snowball roll down a hill? As it picks up speed, it begins to grow! Before long, it's huge and powerful! That's how love is. The more love you share, the more you get. The longer we love, the more we have the capacity to love. If you're hoping to receive more, try giving it away. Then get ready for the snowball effect!

His Abounding Love

*And he passed in front of Moses, proclaiming,
"The LORD, the LORD, the compassionate
and gracious God, slow to anger,
abounding in love and faithfulness."*

EXODUS 34:6 NIV

Have you ever wondered what it means to be
abounding in something? Try replacing the
word *abounding* with the word *wealthy*. God is
wealthy in love and faithfulness. He has more
than enough to share with His kids. Talk about
an inheritance! And He wants us to share
the love. When we accept Jesus and walk in
relationship with Him, we're wealthy with His
love. Make a point to share the wealth today.

Resting in His Abounding Love

"Come to me, all you who are weary and burdened, and I will give you rest. Take my yoke upon you and learn from me, for I am gentle and humble in heart, and you will find rest for your souls. For my yoke is easy and my burden is light."
MATTHEW 11:28–31 NIV

If you're weary—exhausted with life—don't give up hope. God has a place of rest for those who are in relationship with Him. He woos us with His love, opening wide His arms and ushering us into His embrace. There we can hear His heartbeat. Get His perspective. Listen for His words of love that energize us for the tasks ahead. Come, all you who are weary and heavy laden. Rest.

Love—a Living Thing

*Love does not die easily. It is a living
thing. It thrives in the face of all of
life's hazards, save one—neglect.*

JAMES D. BRYDEN

Love is a living, breathing thing. Our love for
God and others is resilient. It can survive a
host of onslaughts. One thing it can't survive,
however, is neglect. We have to tend it. Care
for it. Nurture it. If we follow God's example,
our love will continue to abound, even when
we're having an "off" day. Don't let those
rough days keep you from nurturing love.

On the Rebound

*But you, O Lord, are a compassionate
and gracious God, slow to anger,
abounding in love and faithfulness.*

PSALM 86:15 NIV

It's interesting to see that God's love is both abounding—and rebounding. It keeps coming around to meet us again, even after we've failed. This is because of His compassionate nature. In the same way, we are expected to rebound (bounce back), even after our love for people is challenged. Don't stay away too long. Come back home to love.

Loving through Betrayal

A Savior Who Understands

While he was still speaking, there came a crowd, and the man called Judas, one of the twelve, was leading them. He drew near to Jesus to kiss him.

LUKE 22:47 ESV

Have you ever been betrayed by someone you thought you could trust? Jesus can relate. Imagine how He must have felt watching one of the disciples He loved turn on Him and sell Him out for thirty pieces of silver. Perhaps you feel as though you've been sold out by a friend or loved one. Follow the example of Jesus, who, even in the face of betrayal, chose to forgive.

The Ultimate Betrayal

For while we were still weak, at the right time Christ died for the ungodly.

ROMANS 5:6 ESV

In spite of humankind's betrayal in the Garden of Eden, the Lord still chose to love us by sending His Son as a sacrifice for our sins. Even now, those of us who follow Jesus slip up and betray Him—with our actions, our thoughts, and our motives. How it must break God's heart! But still He offers love, despite His pain. What an amazing example for us to follow.

Covering Offenses

Hatred stirs up strife,
but love covers all offenses.
PROVERBS 10:12 ESV

Once you've been betrayed, it's hard to trust again, isn't it? Sure. Trust needs to be reestablished, rebuilt over time. And our wounds need time to heal. But even when it's hard to trust, we have to keep on loving the person who betrayed us. Why? Because love and trust are two separate things. Trust has to be earned. Love does not. It covers offenses and tears down walls.

All Have Sinned

*For all have sinned and fall
short of the glory of God.*
ROMANS 3:23 NIV

One of the reasons it's so important for us
to continue loving those who have hurt us is
because we never know when it might be our
turn to be forgiven. Sure, we set out to do
the right thing, but even those with the best
of intentions slip up and hurt others. Extend
love and forgiveness at every turn. You never
know when it might be your turn to receive!

Love Softener

Love is never lost. If not reciprocated, it will flow back and soften and purify the heart.
WASHINGTON IRVING

Sometimes we love someone to the point of pain but never receive love back. What does the Lord have to say about this? Should we stop trying? Stop loving? Never! Even if we don't see the desired results, love is always the better option. For when it is not reciprocated by the individual, it will always return to us in one form or another. Love never fails. People fall short, but love never does.

Forgiveness, Love's Key

Love Deeply

Above all, love each other deeply, because
love covers over a multitude of sins.
1 PETER 4:8 NIV

It's human nature to withhold forgiveness
in order to teach the other person a lesson,
but that's not God's way. He doesn't want
us to wait too long to forgive. His desire
is that we're honest with each other when
we're upset. After all, we all sin and fall short.
We have to be willing to go the distance
and do what it takes to mend fences. How
do we accomplish this? Love deeply.

Seeking after Love

Whoever covers an offense seeks love, but he who repeats a matter separates close friends.

PROVERBS 17:9 ESV

We don't get to pick our family members, but we can select our friends. And when we do, we're making a love pact with them. In essence, we're saying: "We're in this for the long haul. We will forgive quickly, love deeply, and keep our conversations private." Good friends seek after love, even when times get tough. *Especially* when times get tough.

Love Covers All Wrongs

"For this reason I say to you, her sins, which are many, have been forgiven, for she loved much; but he who is forgiven little, loves little."
LUKE 7:47 NASB

If you've ever been forgiven for something you considered really grievous, then you know what it means to be grateful! Love covers all wrongs. It also forgives on a grand scale. To extend this kind of forgiveness, you have to genuinely love the other person, both in word and deed. Love big. Forgive big.

Prosperous Love

Love prospers when a fault is forgiven,
but dwelling on it separates close friends.
PROVERBS 17:9 NLT

When we forgive someone who's wronged
us, we're offering proof of our love. No,
forgiving doesn't always mean reconciliation.
Sometimes we need to separate for a season.
Forgiveness doesn't imply an ongoing close
relationship. God often calls friends and
loved ones to take a sabbatical from each
other. But love and forgiveness are still in
order, even in the toughest situations.

Miraculous Love

Where there is great love,
there are always miracles.
WILLA CATHER

Do you believe in miracles? Have you witnessed them personally? God longs for us to see the miraculous on a regular basis. One area in which we witness the supernatural at work is in our relationships with others. Love-based forgiveness is truly miraculous. It says to the other person, "I know that you hurt me deeply, but I make a choice to extend forgiveness because I love you." What a miraculous gift!

Love and Prayer

A Love Song

*By day the L*ORD *directs his love, at night his song is with me—a prayer to the God of my life.*
PSALM 42:8 NIV

Nighttime prayers are so precious. Our last words to God before our head hits the pillow stir our hearts to praise through the night. And what a wonderful gift prayer is. It's an awesome privilege. We get to communicate with the Creator of all! We share our hurts, our pains, our joys, and our questions. Then the Lord responds by speaking to us, whispering words of love and direction.

Extending Love and Prayer

*"But I tell you: Love your enemies and
pray for those who persecute you."*
MATTHEW 5:44 NIV

We usually enjoy praying for others, as long as
we're in good relationship with them. But this
whole "Pray for your enemies" thing is tough!
We don't want to ask God to bless our enemies.
If we're honest, we're usually hoping for the
opposite! But God commands us to love our
enemies and to pray for them too. So who's
on your "enemy" list today? Better get busy!

No Love Withheld

Praise be to God, who has not rejected my prayer or withheld his love from me!
PSALM 66:20 NIV

Sometimes we're afraid to pray because we're upset with the Lord or others. We're afraid that if we get gut-honest with God in our prayers, He might reject us. Not so! He will not withhold His love from us, even when we're mad at Him! He's a big God. He can take it. So get it out. Confess your angst. Then watch as He sets everything right again, with His amazing love leading the way!

Praying. . .and Living

*It is not well for a man to pray
cream and live skim milk.*
HENRY WARD BEECHER

During our prayer time, we often ask God
to bless us. There's nothing wrong with that.
We count on His love and blessings, but
sometimes we don't want to extend those
things to others. If we're going to ask for these
things, then we have to be willing to give them
to the people He places in our lives—even
the ones who are most difficult to love!

A Confession of Love

*I prayed to the Lord my God and confessed:
"Lord, the great and awesome God, who
keeps his covenant of love with those who
love him and keep his commandments."*

DANIEL 9:4 NIV

Prayer is such a wonderful gift. We get to
talk to the King of kings and Lord of lords—
and He responds! Our prayer time is also a
wonderful time to thank God for His great
love toward us. Why not spend some time
praising Him today? Climb up into His lap
and lean your head against His chest. Make a
confession of your love for your Daddy God.

No Fear in Love

No Fear in Love

There is no fear in love. But perfect love drives out fear, because fear has to do with punishment. The one who fears is not made perfect in love.

1 JOHN 4:18 NIV

Oh, what a joy to know that love conquers fear. Think about that for a moment. When fear grips your heart, telling you that you're going to fail at something, God's love drives out that fear. It sends a calming message, one you can rest in. Next time fear slips in, remember it's not from God. He extends perfect love, the only force powerful enough to drive out fear!

Quieted by Love

*"The L*ORD *your God is with you, the mighty*
Warrior who saves. He will take great delight
in you; in his love he will no longer rebuke
you, but will rejoice over you with singing."
ZEPHANIAH 3:17 NIV

If you're a parent, you know what it's like to
rock a baby in your arms, calming him down so
that he can sleep. Your words of love—sweetly
sung—can quiet even the loudest squall. It's
the same when we climb into God's arms.
He quiets us with His love, calms our fears,
and dries our eyes. We drift off to sleep with
His gentle words of love drifting over us.

Love Overcomes Timidity

For the Spirit God gave us does not make us timid, but gives us power, love and self-discipline.
2 TIMOTHY 1:7 NIV

Sometimes we're afraid to share our testimony with others or to talk about our faith. We're timid. We hold back. How wonderful to realize that God gave us a spirit of power, love, and self-discipline. With these three things firmly in place, we're able to open up and share the good news of His love.

Stouthearted Love

When I called, you answered me;
you greatly emboldened me.
PSALM 138:3 NIV

Love doesn't cower in fear. It holds its
head up high and smiles in the face of a
challenge. It cries out, "Be bold! Be strong!"
If you're facing a fearful situation, call out
to God. He will answer you and will give
you the boldness you need to get through
whatever situation you're facing.

Refreshed by Love

Love is the greatest refreshment in life.
PABLO PICASSO

Have you ever reached for a glass of lemonade
on a hot day? It tastes so good, doesn't it?
Hits the spot! Love is like that. When your
friends and loved ones are parched and dry,
they're not aching for a lecture. Instead,
they're longing for a tall glass of love. Ah,
sweet refreshment! Serve up a glass today.

Obedience

What God Requires

"And now, Israel, what does the Lord your
God require of you, but to fear the Lord
your God, to walk in all his ways, to love
him, to serve the Lord your God with all
your heart and with all your soul."
DEUTERONOMY 10:12 ESV

It's fascinating to think that God "requires" us
to love Him. More interesting still is that it's
listed in this scripture, along with walking in
his ways, fearing him, and serving him. These
things work well together, and all the more
when love is tucked in the middle. First we
fear (respect) God; then we show our love by
obeying Him; and that leads to a life of service.

Keep His Word

Jesus answered him, "If anyone loves me, he will keep my word, and my Father will love him, and we will come to him and make our home with him. Whoever does not love me does not keep my words. And the word that you hear is not mine but the Father's who sent me."

JOHN 14:23–24 ESV

Love and obedience have always walked hand in hand. If we love God, we will obey Him. Sure, our flesh doesn't always want to do it, but we'll have the best outcome if we stick with the teachings of the Bible and follow God's precepts to the best of our ability. Love equals obedience.

God Keeps His Covenant

"Understand, therefore, that the LORD your God is indeed God. He is the faithful God who keeps his covenant for a thousand generations and lavishes his unfailing love on those who love him and obey his commands."

DEUTERONOMY 7:9 NLT

A covenant is an agreement between two parties. Sure, we sign on the dotted line— or shake hands on a matter—but we don't always follow through. Not so with God. He always follows through on His agreement, even when we fall short. And He continues to lavish us with His unfailing love when we love Him back and obey His commands.

Disciplined by Love

*Because the L<small>ORD</small> disciplines those he loves,
as a father the son he delights in.*
PROVERBS 3:12 NIV

When we discipline our children, it's because we love them and want the best for them. We're training them to be responsible adults. Same with God. He disciplines us out of love because He wants the very best for us. When we strike out on our own, away from His principles and blessings, He has no choice but to reel us back in. Love always disciplines.

Shaped by Love

We are shaped and fashioned by what we love.
JOHANN WOLFGANG VON GOETHE

Likely you've heard the old expression: "You are what you eat!" We really do "become" what we love, don't we? That's why it's so important to love the Lord our God with all of our hearts. We want to become more like Him. When we love Him, we're shaped and fashioned by His words, His love, and His compassion for humankind.

Tough Love

Tough Love

Love does not delight in evil
but rejoices with the truth.
1 CORINTHIANS 13:6 NIV

It's so hard to watch someone you love get
caught up in a sinful lifestyle—for instance,
your teen is on drugs or your spouse turns to
alcohol. For the first time, your love toward
that person changes slightly. It toughens
up. It gets a backbone. It says, "This far and
no further." And it holds the other person
accountable. Tough love. God's all for it. You
will be too, once you've seen its results.

God's Tough Love

"The LORD is slow to anger, abounding in love and forgiving sin and rebellion. Yet he does not leave the guilty unpunished; he punishes the children for the sin of the fathers to the third and fourth generation."

NUMBERS 14:18 NIV

God is a loving heavenly Father, but He knows how to implement tough love when the situation calls for it. Take Adam and Eve, for instance. Was there ever a more obvious instance of tough love than kicking them out of the garden when they sinned? Yes, God is the author of love—sweet and tough. He believes in consequences. When the need arises, don't be afraid to follow God's example. Love tough.

Love Says No

"Anyone who loves his father or mother
more than me is not worthy of me;
anyone who loves his son or daughter
more than me is not worthy of me."
MATTHEW 10:37 NIV

Sometimes love has to be tough. It has to say no. It has to set limits. If you've been the parent of a teen, you know what it feels like to implement tough love. It's uncomfortable at times and can be a little tricky. You want that other person to know you love him or her, but you have to stick to your guns. God designed love to be both sweet and tough.

The Paradox

"I have found the paradox, that if you love until it hurts, there can be no more hurt, only more love."
MOTHER TERESA

Sometimes love is painful. We love a rebellious teen and he doesn't love us back. We love a spouse who turns his back on us. We love a parent, who is so wrapped up in his work that he can't see beyond it to realize we're crying out for love. Yes, loving others who don't respond can be really difficult—and the way we love them changes—but our love never wanes, even in the hardest of times.

The Receiving End

*And now, O Israel, what does the L*ORD
*your God ask of you but to fear the L*ORD
*your God, to walk in obedience to him, to
love him, to serve the Lord your God with
all your heart and with all your soul.*

DEUTERONOMY 10:12 NIV

If you've hurt others, then perhaps you know
what it feels like to be on the receiving end of
some tough love. There are consequences to
doing the wrong thing, and they often involve
years of proving that you're trustworthy
after letting someone down. Forgiveness
and rebuilding trust take time. Receiving
tough love is uncomfortable, but don't fight
it. Let love win the battle. Relationships will
be restored and hearts will be mended.

Love and Patience

Love Is Patient

*Love is patient, love is kind. It does not envy,
it does not boast, it is not proud. It does not
dishonor others, it is not self-seeking, it is not
easily angered, it keeps no record of wrongs.*
1 CORINTHIANS 13:4–5 NIV

Oh, how impatient we are! We want what we
want—and we want it now! No waiting. But love
isn't impatient. It doesn't demand immediate
service. Instead, love waits patiently on the
sidelines. The next time you feel yourself
losing your patience, take a deep breath.
Remind yourself: love holds on for the ride.

Love's First Duty

The first duty of love is to listen.
PAUL TILLICH

We live in such a fast-paced world that it's hard to keep up! Somewhere between fast food, disposable diapers, and microwaves, we conclude that everything in life needs to move in a hurry. But love shouldn't be rushed. When you really love someone, you're patient with that person. Your first "love duty" is to listen. Simply listen.

Patience and Understanding

A patient man has great understanding,
but one who is quick-tempered displays folly.
PROVERBS 14:29 NIV

Ever wonder why some people are more
understanding than others? They're not quick-
tempered. They take the time to think things
through. That's how love is. It doesn't knee-
jerk. Doesn't react quickly. Love responds with
understanding and thoughtfulness, not foolish
words or a sharp retort. Take a deep breath,
my friend! Let love and patience rule the day!

Patience— a Fine Companion

Patience is the companion of wisdom.
AUGUSTINE

Patience is a wonderful companion of wisdom, and we could also say that patience is a fine companion of love, as well. For when you love others, you're naturally patient with them. You let them think things through. You give them time to change when change is necessary. You don't rush them toward the goal. Patience and love—try them on for size today.

Joyful in Hope

*Be joyful in hope, patient in
affliction, faithful in prayer.*
ROMANS 12:12 NIV

Hope is a precious commodity, isn't it?
When we're hopeful, we can endure almost
anything. It gives us the ability to patiently
endure even the toughest of challenges.
And hope is also a wonderful companion
to love. When you love people, you find
yourself treating them with more patience.
You're hopeful that the relationships God
has blessed you with are going to grow
stronger and stronger as time goes by.

Building
Others Up

Built up by Love

Love and faithfulness keep a king safe;
through love his throne is made secure.
PROVERBS 20:28 NIV

Did you know it takes a thousand " 'Atta girls!"
to overcome one critical word? It's human
nature to hang on to the negative words.
Criticism rings loud and clear in our ears, but
not praise. That's why it's so important to
build others up with your love. Speak positive,
affirming words. Encourage. Uplift. Make the
other person feel safe and secure around
you. Love doesn't tear down. It builds up.

Only What Is Helpful

Do not let any unwholesome talk come out
of your mouths, but only what is helpful for
building others up according to their needs,
that it may benefit those who listen.

EPHESIANS 4:29 NIV

Oh, how we love to talk about others. Usually
we don't set out to gossip or cause pain, but
often that's how things end up. We get carried
away. We share our "concerns" with others.
God longs for us to guard what we say, dwelling
only on what is helpful. That's how love
operates. It compels us to build others up, not
cut them down. May every word be beneficial.

Love—the Perfect Sweetener

Life is the flower for which love is the honey.
VICTOR HUGO

According to the Bible, the power of life and death is in the tongue. Words can make or break us. We need to speak words of love while we have the time, especially with our children. Whether we're talking to our friends, spouse, or children, what comes out of our mouths is important. We have to think of love as we would a cube of sugar. It's the perfect sweetener.

Love. . .the Best Medicine

Love is the best medicine, and there is more than enough to go around once you open your heart.

JULIE MARIE

Perhaps you've heard it said that laughter is the best medicine. Truly, love is the best medicine. When administered properly— and at the right time—it can mean the difference between life and death. Think of the people the Lord has placed in your life, the ones who most need your words of life. Today why not administer the medicine they need? Open your heart and pour out love.